D0368539

Renoir

A THOMAS NELSON BOOK

First published in 1993 by Thomas Nelson Publishers, Nashville, Tennessee.

Copyright © 1993 by Magnolia Editions Limited

10 9 8 7 6 5 4 3 2 1

Library of Congress Cataloguing in Publication Data is available.

Library of Congress Card
93-83511

ISBN 0-7852-8301-3

MINIATURE ART MASTERS
IMPRESSIONISTS: RENOIR
was prepared and produced by
Magnolia Editions Limited,
15 West 26th Street, New York, N.Y. 10010

Editor: Karla Olson
Art Director: Jeff Batzli
Designer: Susan Livingston
Photography Editor: Ede Rothaus

Printed in Hong Kong and bound in China

Renoir

Gerhard Gruitrooy

NELSON REGENCY
A Division of Thomas Nelson, Inc.

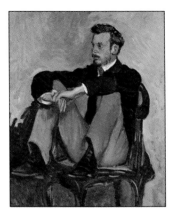

Portrait of Pierre-Auguste Renoir,

By Frédéric Bazille; 1867; Oil on canvas;
48″ × 42 ⅛″ (122 × 107 cm);
Musée d'Orsay, Paris

INTRODUCTION

Renoir was one of the leading Impressionist artists, but was perhaps the most conservative of the group. His work is not as introspective as that of others, such as Claude Monet, and he did not follow a theory. Uneasy with the approach of focusing merely on visual "impressions," he later remarked that "it is in the museum that one learns to paint," which is almost heresy to Impressionism.

Renoir clearly preferred to depict the pleasing aspects of life and to avoid any contradictions posed by the industrial and urban development during the second half of the nineteenth century. His world, as recorded in his paintings, consisted rather of beautiful people enjoying themselves. His increasingly solid rendering of the figures, which owed much to an

appreciation of the Old Masters, allowed him to achieve a more formal and monumental quality, visible particularly in his later works. Air and atmosphere, which were so prominent in Monet's landscapes, play only a minor role in Renoir's. His palette of brilliant, translucent colors is more subtle than that of Monet, who preferred more aggressive primary colors (red, yellow, blue).

Renoir was born in Limoges and he started as a painter of porcelain at one of the local manufacturers, which predisposed him to a lighter and sweeter color range. In 1861 he went to study with the academic painter Charles Gleyre, in whose classes he met Claude Monet, Frédéric Bazille, and Alfred Sisley. He also regularly visited the Louvre, where he admired the Baroque paintings of Antoine Watteau and Francois Boucher. Their idyllic, bucolic scenes of people in undis-

turbed natural environments and their airy and light colors influenced Renoir throughout his career.

Renoir always felt the need for thorough study and was never quite satisfied with the purely visual aspects of Impressionism as pursued by Monet. Nonetheless, the two artists painted together out-of-doors on a number of occasions, in particular at "La Grenouillère" on the Seine.

Like most of the Impressionists, Renoir submitted paintings to the official Salon, the only showcase of any standing in Paris at the time. Because the academic and traditional jury was extremely conservative in their selection of works, most pieces entered by members of the radical Impressionist group were rejected. However, the jury accepted some of Renoir's portraits that they considered executed according to classical rules of drawing and form. Consequently,

Renoir, who had already shown dissatisfaction with Impressionism as followed by some of his artist friends, declined to exhibit in their show of 1884.

After a visit to Italy in 1881 Renoir's compositions became even more restrained and his Impressionism less spontaneous. Under the influence of the Old Masters, he began to prepare his canvases by making studies and sketches. Also, he concentrated more exclusively on the human figure, on nudes in particular, abandoning almost entirely his earlier subjects of portraits, landscapes, flower still lifes, and figure groups set in cafes and dancehalls. From the 1890s on he adopted a more coloristic style, perhaps influenced by the brilliance of light he observed on his trips to North Africa. His favorite color scheme became pink and red, colors which he exploited in numerous paintings.

In 1906 he settled in Cagnes, in the south of France, but his hands were already crippled by arthritis and he was barely able to hold a paintbrush. As a result, his late works are more loosely painted. He also turned to sculpture, the ideas for which he "dictated" to an assistant.

PORTRAIT OF JEAN-FRÉDÉRIC BAZILLE

1867; OIL ON CANVAS;
41 ¾" × 29 ⅛" (106 × 74 CM);
MUSÉE D'ORSAY, PARIS

Possibly painted in the rue Visconti studio in Paris at the same time as Bazille's portrait of Renoir (see page 4), this portrait shows the artist's friend working on his painting "The Heron," now in the Musée Fabre in Montpellier, Bazille's native town. The chair in each portrait might actually be the same one. Together with Sisley and Pissarro, the two friends protested without success against their exclusion from the official Salon. Bazille died as a volunteer in the Franco-Prussian war in November of 1870.

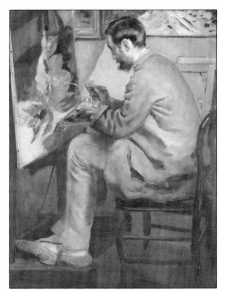

ROMAINE LACAUX

1864; OIL ON CANVAS;
31 $\frac{7}{8}$" × 25 $\frac{5}{8}$" (81 × 65 CM);
MUSEUM OF ART, CLEVELAND

One of the artist's early commissioned works and one of the many portraits of children and adolescents that he did in his lifetime. Renoir painted the young girl with some bright color effects that look like enamel. Her classic frontal pose and the joined hands resting on her lap are elements reminiscent of portraits by Velazquez. But this piece also brings to mind works by Ingres, whom Renoir admired because of his ability to replicate on canvas the qualities of human flesh.

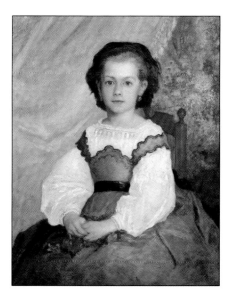

LISE WITH UMBRELLA

1867; OIL ON CANVAS;
72 ½" × 45 ¼" (184 × 115 CM);
FOLKWANG MUSEUM, ESSEN

During the summer of 1867, Renoir went with his
model Lise Tréhot to the forest at Chailly-en-Bière
near Paris, where he painted her outdoors (en
plein air). The life-size figure has a monumental
quality. Standing in a clearing of the woods, Lise is
displayed from head to toe wearing a white dress
with a sash. Her head is turned slightly to her right
so that only two-thirds of it can be seen. She holds
an umbrella with her left arm while with her right
she is arranging the folds of her dress. This paint-
ing was exhibited at the Salon the following year.

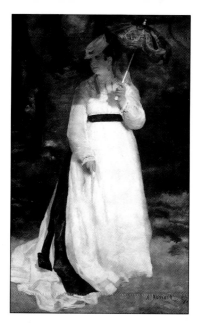

PORTRAIT OF ALFRED AND MARIE SISLEY

1868; OIL ON CANVAS;
41 $^3/_8$" × 29 $^1/_2$" (105 × 75 CM);
WALLRAF-RICHARTZ MUSEUM, COLOGNE

The Impressionist painter Alfred Sisley (1839–1899), a friend of Renoir's since drawing classes at the studio of Charles Gleyre, and his wife, Marie, are portrayed here in elegant dress. The husband, offering his arm, is facing his wife as if he is just about to propose something to her. Marie, however, appears oblivious to the conversation. The refreshing colors and the intimate familiarity of the sitters make this painting an important document of the artists' friendship.

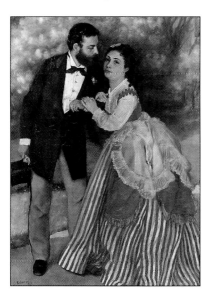

La Grenouillère

1868; OIL ON CANVAS;
23 ¼" × 31 ½" (59 × 80 CM);
HERMITAGE, ST. PETERSBURG

The same scene of the island of Croissy on the
Seine river between Bougival and Argenteuil
was painted by Claude Monet (in a painting
that is now in the collection of the Metropolitan
Museum of Art, New York) side by side with
Renoir in a friendly contest between the artists.
The location offered Parisians relaxation and con-
tact with nature during traditional Sunday visits.
The technique of color dabs was particularly suit-
able to re-create on canvas the reflections in the
water of trees, and the dresses of the crowd.

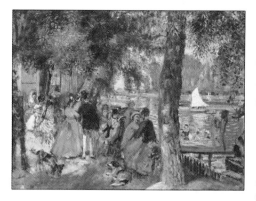

BARGES ON THE SEINE RIVER

1869; OIL ON CANVAS;
18" × 25 ¼" (46 × 64 CM);
MUSÉE DE'ORSAY, PARIS

> This is one of Renoir's earliest landscapes without
> figures. The river is seen from an elevated view-
> point where grass and shrubs fill the foreground. A
> number of barges are lined up on the water,
> echoing the bend of the river near the horizon.
> The range of subtle gray tones are reminiscent of
> the works of Gustave Courbet (1819–1877),
> whom Renoir had met in 1865 and whose realism
> he admired. The overall impression, however,
> proves to be more subtle and vibrant than the
> works of the older master.

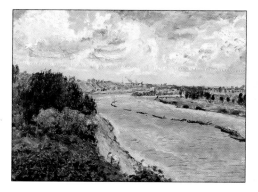

BATHER WITH A DOG
1870; OIL ON CANVAS;
72 ½" × 45 ¼" (184 × 115 CM);
MUSEU DE ARTE, SÃO PAULO, BRAZIL

The Salon of 1870 accepted this painting together with another work by Renoir. The critics were more complimentary than in the early years, noting the affinity to works by Gustave Courbet (1819–1877) and Camille Corot (1796–1875). The woman, standing in a classical pose similar to that of antique sculptures such as the Venus Medici, is about to take a bath in the river seen behind the willows on the left. Her clothes lie in disorder on the grass and even the little dog has found a comfortable place to rest. An odd addition is the reclining female companion wearing a thoughtful expression.

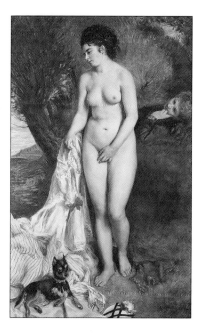

WALK IN THE GARDEN
1870; OIL ON CANVAS;
31 ⅞" × 25 ½" (81 × 65 CM);
THE J. PAUL GETTY MUSEUM, MALIBU

The attitude of the couple in this painting is com-
parable to that of the Sisleys (see page 16), but
in all its grandeur this work is painted in a much
smaller scale. The brushstrokes are tighter and the
treatment of light and shadow is more vibrant.
The overall result is a compressed and condensed
composition. Bowing slightly forward, the man
offers his arm to the woman to help her climb the
slope. Her figure appears in full sunlight while
the man's face is overshadowed by the tree and a
hat. His inviting gesture is met by a hesitant
response from the woman.

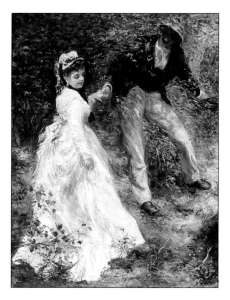

WOMAN WITH PARROT

1871; OIL ON CANVAS;
35 $\frac{7}{8}$" × 25 $\frac{1}{2}$" (91 × 65 CM);
THE SOLOMON R. GUGGENHEIM MUSEUM,
NEW YORK

The same subject was painted five years earlier
by Manet. Renoir's interpretation differs consider-
ably, as it shows a very personal relationship
between the woman and the bird. She seems to
be trying to feed the bird, who is sitting on her
hand, and we might even assume she is talking
to it. The luxurious setting includes plants, a bird-
cage, and decorative wallpaper. The woman,
Renoir's favorite model, Lise, wears an opulent
satin dress.

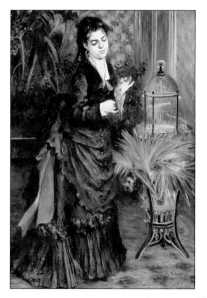

CLAUDE MONET READING

1872; OIL ON CANVAS;
24" × 19 5/8" (61 × 50 CM);
MUSÉE MARMOTTAN, PARIS

Renoir's friendship with Monet is documented in a couple of portraits of his fellow artist. Here, Monet is rendered in profile, smoking a pipe while reading a paper or a pamphlet. His head slightly inclined, he is leaning over the back of a chair, which is visible in the triangle formed by his upper and lower arms. The head remains overshadowed by his round bowler. The Impressionistic brushwork, most obvious in the hat and the smoke, can be seen as an homage to Monet.

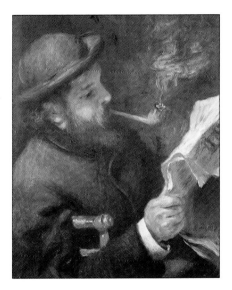

Riders in the Bois de Boulogne
1872–1873; Oil on canvas;
102 ¾" × 89" (261 × 226 cm);
Kunsthalle, Hamburg

A proud woman on horseback accompanied by an adolescent boy is riding in the Bois de Boulogne, a forest on the outskirts of Paris. The cool nobility of the scene is underlined by pale gray-green and bluish colors. The woman's aloof gaze and her severe black dress with top hat and veil led some to call her an amazon. Destined for the Salon, where it was rejected, the painting was executed at the military school at l'Hôtel des Invalides. Darras, the officer whose wife posed for the picture, criticized the coloring: "Believe me...I have never seen blue horses."

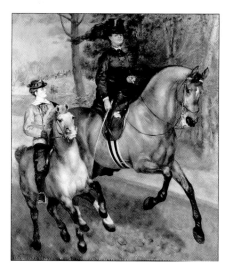

THE THEATER BOX

1874; OIL ON CANVAS;
31 ½" × 25 ¼" (80 × 64 cm);
THE COURTAULD INSTITUTE, LONDON

One of Renoir's elaborate, highly finished canvases, this piece is without doubt one of his masterpieces. An important part of elegant modern Parisian life, the theater box was a popular subject among artists. The focus of attention is clearly the woman's finely rendered face. Her black and white striped gown, the long white gloves, her precious pearl necklace, and the delicate flowers on her bodice all make her a figure from the world of elegance, although some have recognized in her a typical cocotte. The model was Nini, otherwise known as *Geule-de-Raie,* or "fish-face"; her companion is the artist's brother Edmond.

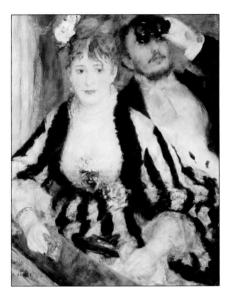

BALLERINA

1874; OIL ON CANVAS;
55 7/8" × 36 5/8" (142 × 93 CM);
NATIONAL GALLERY OF ART,
WASHINGTON, D.C.

A young blond ballet dancer is lifting her tulle skirts
with a graceful gesture. True to life, she has a fine
and nervous elegance. The response to the presen-
tation of this work at its first public showing at the
Impressionist show in 1874 was negative. The crit-
ics denounced its lack of good drawing, referring to
the girl's legs as being "slack like her gown."
Today it is exactly this dreamlike quality that is
most appreciated in Renoir's work.

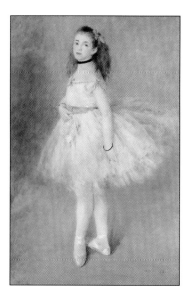

Charles Le Cœur in the Garden

1874; Oil on canvas;
16 ½" × 11 ⅜" (42 × 29 cm);
Musée d'Orsay, Paris

The inscription on the top right, "O Galand Jard" ("To the gallant gardener"), is a dedication to the sitter, the architect and artist's friend Charles Le Cœur. Painted during the summer in the garden of Fontenay-aux-Roses, this is one of the few full-length male portraits by Renoir. The bold brush-strokes of the white suit are almost independent of the rest of the picture. Renoir's relationship with Le Cœur ended abruptly when a love letter he had written to Le Cœur's sixteen-year-old daughter, Marie, was discovered.

PATH IN THE HIGH GRASS

1874; OIL ON CANVAS;
23 ¼" × 29 ⅛" (59 × 74 CM);
MUSÉE D'ORSAY, PARIS

Grass turned yellow by the sun, heat rising from
the ground, and an air full of the scents of herbs
and flowers are the protagonists of this painting.
The two figure groups blend completely into the
landscape as accessories. The closer one consists of
a woman carrying a red parasol with two children
dressed in blue marching ahead of her through the
field. A thin veil of white indicates the "path." Two
more figures coming down the slope can be made
out in the distance.

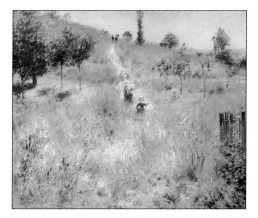

THE LOVERS
1875; OIL ON CANVAS;
68 ⁷/₈" × 51 ¹/₄" (175 × 130 CM);
NARODNI GALLERY, PRAGUE

The title of this painting is made clear by the man's
amorous advances and the bouquets of flowers,
one being a freshly picked bunch of poppies and
wild herbs, the other a group of cultivated flowers
wrapped in paper. The couple is sitting under a tree
whose leaves protect them from the heat of the
summer. The slope explains the man's reclining
position and the woman's upright pose. The vibra-
tions of silvery tones show Renoir's attempt to
meld the figures with the natural atmosphere
around them. The models were the actress
Henriette Henriot and the painter Franc-Lamy.

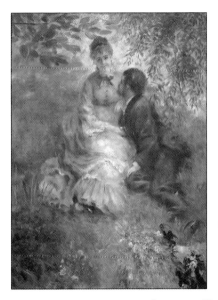

WOMAN READING (LA LISEUSE)
1874; OIL ON CANVAS;
17 ³/₄" × 14 ½" (45 × 37CM);
MUSÉE D'ORSAY, PARIS

This is one of Renoir's best known paintings. Its private character becomes evident when compared with the relatively small size of the original. Sitting at an angle, head and book tilted slightly to the left, the young woman apparently finds pleasure in her reading, indicated by the soft smile on her face. Her light-colored skin and her straw-blond hair contrast effectively with her blue dress. The same color combination is repeated in the background. The close-up perspective makes the viewer feel like an intruder, and one might expect the woman to look up from her book at any moment.

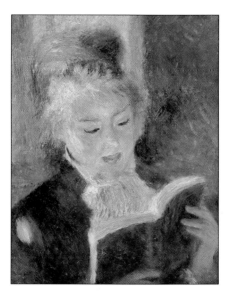

STUDY: TORSO, SUNLIGHT EFFECT

CIRCA 1876; OIL ON CANVAS;
31 ½" × 25 ¼" (80 × 64 CM);
MUSÉE D'ORSAY, PARIS

The model for this nude study was Alma Henriette Lebœuf, called Anna, who was only nineteen at the time of this painting. She seems to emerge from the sun-struck verdant landscape like a flourishing young Venus. Her body is treated with brushstrokes of light and color similar to those of the background, thus melting her perfectly into the surrounding space. Her torso has been called by some a triumph of luminous softness and criticized by others as being that of a putrefying corpse. Today Renoir's technique seems more convincing than the cold and often colorless nudes of the Salon painters.

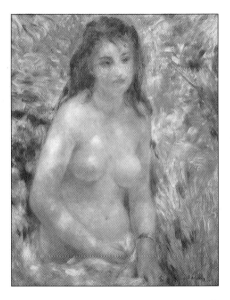

LITTLE GIRL WITH WATERING-CAN

1876; OIL ON CANVAS;
39 ³/₈" × 28 ³/₄" (100 × 73 CM);
NATIONAL GALLERY OF ART,
WASHINGTON, D.C.

Because this scene is depicted from the perspective of the little girl, the viewer shares with her the same outlook on nature. The garden with its green grass and its flowers becomes the world seen through her eyes. The figure is fused with the landscape through the ingenious technique of applying the brilliantly colored brushstrokes to the canvas like a web. The blue of her dress and eyes, as well as the red of her bow and lips, are repeated in the flowers surrounding her. In its spontaneity and gaiety, this scene evokes memories of childhood.

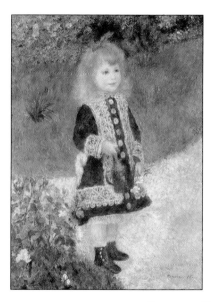

The Swing

1876; Oil on canvas;
36 ¼" × 28 ¾" (92 × 73 cm);
Musée d'Orsay, Paris

Like many other Impressionist works in this museum, *The Swing* entered the collection in 1896 as part of the bequest of the painter Gustave Caillebotte, who was one of Renoir's close friends and a strong supporter of the young Impressionists. The effects of shimmering light on the woman's dress underline the grace of a sunny day in the garden of the artist's studio in Montmartre. The woman, who is about to set a foot on the swing, is a model named Jeanne. The blue of the bows on her dress is repeated throughout the painting.

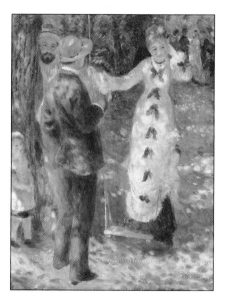

THE PERGOLA
1876; OIL ON CANVAS;
31 ¾″ × 25 ½″ (81 × 65 CM);
PUSHKIN MUSEUM, MOSCOW

Renoir's stylistic development led more and more
to a fusion of human figures and nature. *The
Pergola,* which was painted at an outdoor dance-
hall called Moulin de la Galette, is a prelude to his
famous painting of a scene from that site (see
page 52). Here, the woman, seen from the back,
introduces the viewer to the center of the composi-
tion where a couple unaware of the intruder is
sitting at a table covered with glasses and drinks.
The man standing behind them responds to the
first woman by looking back at her. The male
sitters were probably the painter's friends Monet
and Sisley.

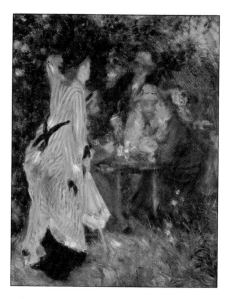

BALL AT THE MOULIN DE LA GALETTE, MONTMARTRE

1876; OIL ON CANVAS;
51 ½" × 68 ⅞" (131 × 175 CM);
MUSÉE D'ORSAY, PARIS

The Moulin de la Galette, which took its name from an old windmill, was a popular open-air dancehall at the Montmartre hill in Paris where young Parisians used to dance on Sunday afternoons. The few stable elements, such as chairs, benches, and tables, are pushed to the edges in order to leave as much room as possible for the main purpose of this locale: the dance. Couples sprinkled with sunlight are dancing or talking to one another in a free and relaxed atmosphere. Several eyes are looking out of the picture as if to invite a casual stroller to join them in their gaiety.

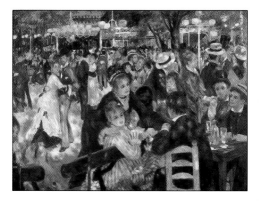

BALL AT THE MOULIN DE LA GALETTE, MONTMARTRE (DETAIL)

The woman in the foreground appears to be engaged in a flirtatious conversation with the young man in front of her. Leaning forward to better hear what he is saying, the woman is resting her arms on the back of the bench and on the shoulder of a woman below her. Judging from the reaction of the younger woman, who is turning her head away and gazing dreamily into the distance, we might assume that the man is making some rather audacious suggestions.

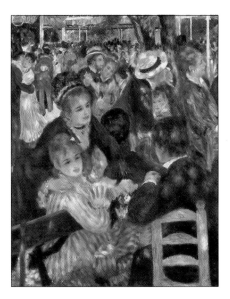

WOMAN AFTER THE BATH
1876; OIL ON CANVAS;
36 5/8" × 28 3/4" (93 × 73 CM);
NEUE GALERIE, VIENNA

The model for this portrait is Anne Lebouf, who
also sat for *Study: Torso, Sunlight Effect* (see page
44). Although painted the same year, the girl
appears more mature in this work. The classic pose
and the even light of the interior are reminiscent of
Manet's more restrained style. Perhaps Renoir was
reconsidering his own achievements after the harsh
criticism *Torso* had received at its first public show-
ing. In any case, he soon dismissed this phase and
returned to his own interpretation of womankind.

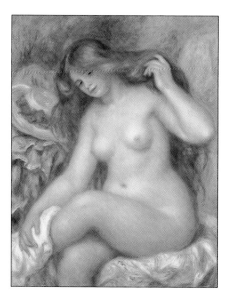

LADY IN BLACK

CIRCA 1876; OIL ON CANVAS;
25 1/8" × 21 1/8" (63 × 53 CM);
HERMITAGE, ST. PETERSBURG

A young woman with a calm smile on her face is gazing out of the picture into the distance. Her black dress contrasts with the white, open collar and sleeves. She has been identified by some scholars as the model Anna, while others are inclined to see in the woman portrayed Mme. Georges Hartmann, wife of a well-known music publisher.

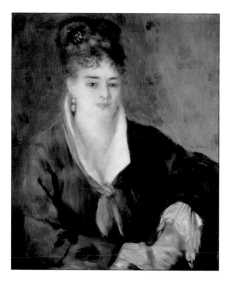

JEANNE SAMARY IN A LOW-NECKED DRESS

1877; OIL ON CANVAS;
22" × 18 ⅛" (56 × 46 CM);
PUSHKIN MUSEUM, MOSCOW

Jeanne Samary (1857–1890), an actress at the Comédie Française, lived in Renoir's neighborhood and posed several times for the artist. Exhibited at the third Impressionist exhibition, this portrait was favorably received by some critics. The expression of her questioning eyes and the thoughtful pose of her hand touching her cheek tone down some of the vibrancy and brilliance of the painted surface, but heighten the intensity of her character.

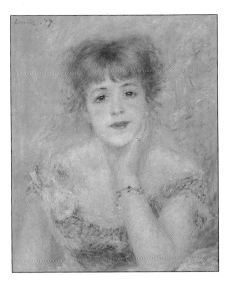

Madame Charpentier with Her Children

1878; Oil on canvas;
60 ¼" × 74 ⅜" (153 × 189 cm);
Metropolitan Museum of Art, New York

When this painting entered the museum's collections in 1907, it was still considered too modern by some, although it had already been acclaimed at its first showing at the Salon of 1879. The wife of a well-known publisher, Mrs. Charpentier is seen together with her two children in a room with Japanese decor. This is a group portrait of charming intimacy. The dominating figure of the mother seems to protect the two girls while the older daughter sits on the back of a watchful St. Bernard.

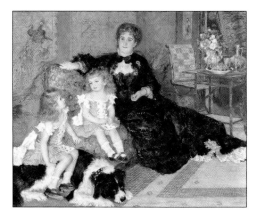

ROWERS AT CHATOU

1879; OIL ON CANVAS;
31 ⅞" × 39 ⅜" (81 × 100 CM);
NATIONAL GALLERY OF ART,
WASHINGTON, D.C.

For the first time, here appears Aline Charigot, the artist's future wife, whom he had recently met. The color of her red dress is echoed in the boat cutting obliquely into the picture plane. The man dressed in white is Renoir's brother Edmond, who had published an article on the artist earlier the same year. Aline and Edmond are about to step into the rowboat in which a young man is already prepared to greet his new clients. Outings to the island of Chatou were a regular pastime for Renoir and his friends.

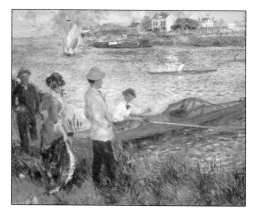

At "La Grenouillère" (Woman Outdoors)

1879; Oil on canvas;
28 ³⁄₈" × 36 ¼" (72 × 92 cm);
Musée d'Orsay, Paris

Located on the island of Chatou on the Seine river,
this site offered tourists and visitors on Sunday
excursions various restaurants and other amenities
(see also pages 74 and 76). Renoir had a particu-
lar liking for the restaurant Fournaise, which he
eventually commemorated in the famous *Luncheon
of a Boating Party* (see page 76). Alphonsine
Fournaise, the daughter of the owner of Fournaise,
may have been the model for this painting. In the
background is a railway bridge that occasionally
was depicted by the artist.

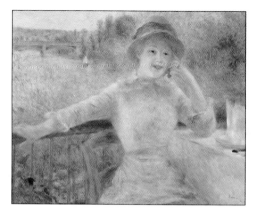

WOMAN WITH A FAN

1880; OIL ON CAVAS;
25 ½" × 19 ¾" (65 × 50 CM);
HERMITAGE, ST. PETERSBURG

As in At "La Grenouillère" (see page 66) the model may be Alphonsine Fournaise. The frontal pose is accentuated by the fan held parallel to the picture plane. Only a slight inclination of the woman's head and her smile break the rigid geometry of the composition. But it is the colors— particularly the yellow of the fan, which was perhaps a reflection of the popularity of Japanese items during those years—that give this portrait its liveliness and vibrancy.

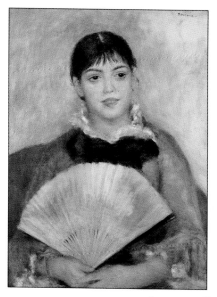

IRÈNE CAHEN D'ANVERS

1880; OIL ON CANVAS;
25 ⅝" × 21 ¼" (65 × 54 CM);
E.G. BÜHRLE COLLECTION, ZURICH

This portrait was finished in only two sessions at the house of the d'Anvers family in Paris. Irène's father, the banker Louis Cahen d'Anvers, also commissioned a double portrait of his two younger daughters, for which the artist received only the modest compensation of 150 francs. Irène, who was about eight years old at the time Renoir painted her, lived until 1963. Her gentle features, the beautiful long red hair falling over her shoulder, and her small hands folded on her lap are rendered with an impressive delicacy.

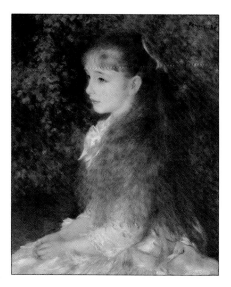

A Bouquet of Flowers

CIRCA 1880–1882; OIL ON CANVAS;
21 ¼" × 26" (54 × 66 CM);
ISRAEL MUSEUM, GALLERY OF MODERN ART,
JERUSALEM

More intrigued by the human body or scenes from everyday life, Renoir painted only a small number of still lifes, most of which were renderings of flowers. Renoir's still lifes bear some stylistic similarities to those of Claude Monet. These flowers are loosely arranged in a simple vase placed on a table. The neutral wall behind allows the petals to display all their richness and subtlety.

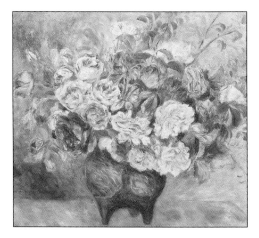

WOMAN WITH GIRL ON A TERRACE

1881; OIL ON CANVAS;
39 3/8" × 31 1/2" (100 × 80 CM);
ART INSTITUTE, CHICAGO

This is a straightforward and effective likeness of a pretty woman with her equally pretty daughter. The colors and the atmosphere of the painting transmit the radiance and glow of a summer day. The location is probably the terrace of the restaurant Fournaise at Chatou (see also pages 64 and 76). The sitter is the young actress Darlaud, who eventually joined the Comédie Française. The painting was immediately purchased by the influential art dealer Durand-Ruel.

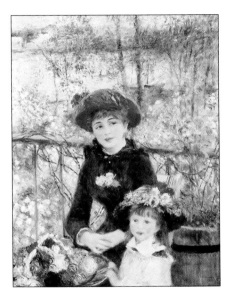

LUNCHEON OF A BOATING PARTY

1881; OIL ON CANVAS;
51" × 68" (129.5 × 172.7CM);
THE PHILLIPS COLLECTION,
WASHINGTON, D.C.

This outing on an island of the Seine river at Chatou takes place on the terrace of the restaurant Fournaise, a well-known meeting place for oarsmen. Almost all of the sitters can be identified. The woman on the lower left is Aline Charigot, Renoir's future wife. On the right wearing a T-shirt and a straw hat is the painter Gustave Caillebotte. The fresh colors and the still life of a finished luncheon make this conversation piece outdoors (*en plein air*) one of the most successful and charming works by the artist.

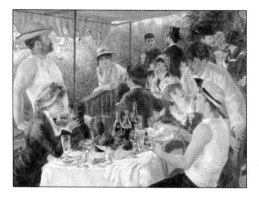

PORTRAIT OF RICHARD WAGNER
JANUARY 15, 1882; OIL ON CANVAS;
20 ½″ × 17 ¾″ (52 × 45 CM);
MUSÉE D'ORSAY, PARIS

On January 15, 1882, Renoir sketched this por-
trait of Richard Wagner during the latter's stay
in Palermo. Jules de Brayer, a French admirer of
the composer, had commissioned this work from
Renoir through a letter sent to Sicily. The maestro
conceded only half an hour for the session and
was eventually dissatisfied with the result. Given
the short time he had, Renoir captured the
composer's characteristic features astonishingly
correctly. Wagner had just finished his last master-
piece, the opera *Parsifal*, and he died the
following year in Venice.

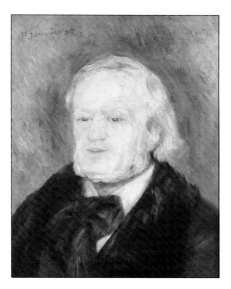

DANCE IN THE CITY

1883; OIL ON CANVAS;
70 7/8" × 35 1/2" (180 × 90 CM);
MUSÉE D'ORSAY, PARIS

Dance in the City was conceived with its counterpart, *Dance in the Country* (see page 82), in mind. Renoir intended to contrast the elegant lifestyle of city dwellers with the simpler earth-bound traditions of country people. Here, the woman, dressed in a sumptuous satin gown, is seen from behind. Her dance partner, wearing a tuxedo, is barely visible, and their relationship to each other is not clearly defined. Aloofness and distance seem to prevail over intimacy and pleasure. The palm tree in the background and the highly finished state of this work add to the air of preciousness.

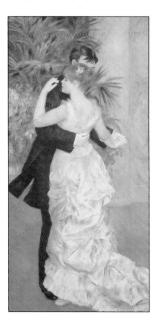

DANCE IN THE COUNTRY

1883; OIL ON CANVAS;
70 $7/8$" × 35 $1/2$" (180 × 90 CM);
MUSÉE D'ORSAY, PARIS

While in *Dance in the City* (see page 80) the
models were the painters Suzanne Valadon and
Paul Lothe, here Renoir's wife, Aline, is dancing
with Paul Lothe. Whether this arrangement
was intentional or merely accidental is hard to
determine. In any event, Aline seems to express
perfectly the emotional, loving woman who is not
afraid to show her feelings toward her companion.
She looks out of the picture with pride and dignity,
obviously enjoying the amusement.

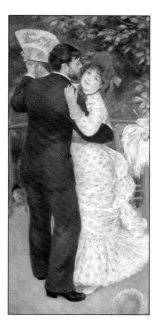

THE UMBRELLAS

1883; OIL ON CANVAS;
70 7/8" × 45 1/4" (180 × 115 CM);
NATIONAL GALLERY, LONDON

Renoir explored the highly problematic use of black paint in a number of paintings. Nowhere is this color more pervasive than in this painting. Admittedly, Renoir mixed a good deal of blue into the paint so that it is lively and able to reflect light in varying degrees. However, the representation of umbrellas is a tour de force worthy of an artist like Renoir. The plainly dressed woman carrying an empty basket, the interior of which is also black, seems too poor to afford an umbrella, but there is a young gentlemen behind her ready to offer his protection.

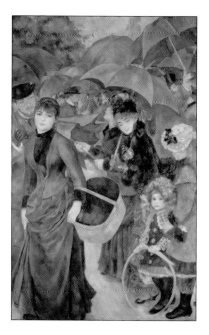

TWO GIRLS AT THE PIANO

1892; OIL ON CANVAS;
45 ⅝" × 35 ½" (116 × 90 CM);
MUSÉE D'ORSAY, PARIS

Playing the piano was almost obligatory for young women of the middle and upper bourgeoisie in the late nineteenth century. It not only was considered good taste, but also was a form of entertainment at parties or social gatherings at a time when neither gramophones nor radios were known. It is therefore not surprising to find several paintings with this subject in Renoir's work. These two girls—one playing, the other looking at the sheets of music—the detailed description of the middle-class living room, and the immediate access for the viewer make this the most charming example.

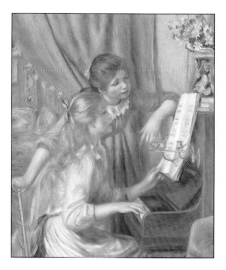

Road to Louveciennes

1895; Oil on canvas;
12 ½" × 16 ⅛" (32 × 41cm);
Musée des Beaux-Arts, Lille

A sand-colored road framed on each side by thin poplar trees cuts across the picture plane. We are watching the street from a clearing on the right, perhaps the driveway to a farmhouse. A horse-drawn cart is arriving, but it is difficult to say how far away it actually is since its scale is not clear. According to the painting's title, the road leads to Louveciennes, where Renoir's parents lived for many years. This is a somewhat melancholy picture compared to the artist's sun-drenched landscapes.

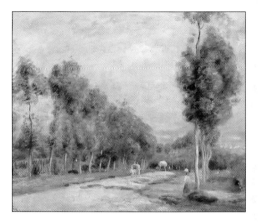

Red Pagliaccio

1909; Oil on canvas;
50 3/8" × 34 5/8" (128 × 88 cm);
Orangerie, Paris

The boy in the traditional carnival costume of Pagliaccio, an Italian character, is the artist's youngest son, Claude. Born on August 4, 1901, the boy was commonly called Coco by his family. At the time he executed this work, Renoir was already suffering from rheumatic attacks, which at times made it impossible for him to paint. The mild climate of the south of France, where this painting was executed, alleviated his pain to some degree. The immobile pose of the boy seems to contradict the gaiety of his red costume.

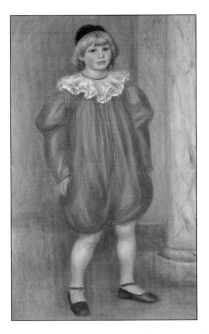

GABRIELLE WITH A ROSE

1911; OIL ON CANVAS;
21 ⅞" × 18 ½" (55.7 × 47 CM);
MUSÉE D'ORSAY, PARIS

The artist's favorite model for about 20 years, Gabrielle Renard, a cousin of Renoir's wife, Aline, entered Renoir's household in 1894 at the age of sixteen. She lived with the family for many years until her marriage to the American painter Conrad Slade in 1915. Here, in her early thirties, she is seen as a mature woman. Sitting at a dressing table with her blouse open, she tries to fix a rose in her hair. The colors were applied with regular brushstrokes, giving the painting a sense of unity and harmony.

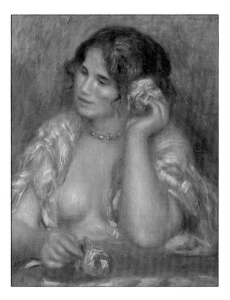

Index of Artworks

Photography Credits